CLASS ACTS

T0353304

CLASS ACTS

The Wish Collector
OLADIPO AGBOLUAJE

The Acme Thunderer
LIN COGHLAN

Of the Terrifying Events on the Hamelin Estate
PHILIP OSMENT

OBERON BOOKS
LONDON

First published in 2009 by Oberon Books Ltd
521 Caledonian Road, London N7 9RH
Tel: 020 7607 3637 / Fax: 020 7607 3629
e-mail: info@oberonbooks.comweb: www.oberonbooks.com

Reprinted 2010

Contents

'I FELT LIKE I WAS KING OF THE WORLD': Life-changing Theatre

I felt like I was king of the world.
Child performing in Unicorn Class Acts festival

At the Unicorn, we create theatre because it changes lives. We know from our own experiences as children (and as adults) the power it can have. Those changes may be small but significant: a moment of emotional growth, a new intellectual insight, a release of imagination. Or they can be huge: transformations that last a lifetime.

This may all sound a bit ambitious if you've picked up this book – as we hope you may have – looking for something to make an engaging end of summer term activity for a class leaving Primary School. Or maybe you've found yourself committed to do some drama with a large group of young people for whom plays aimed at teenage performers don't feel quite right. You may not be a drama specialist at all – and you would have that in common with the directors who premiered these plays, rehearsing their often challenging classes of ten and eleven year olds in plays which, far from being 'tried and tested', were being reworked throughout the process. They weren't looking for a transcendent life-changing experience so much as to get the show on at all. And at times, as always happens, it felt like even that was impossible.

So take heart and skip to the next section, filled with practical advice based on those teachers' experience. Class Acts *was* a remarkable event for its young participants (and for the adults involved) but all our efforts at the time went the same way yours will – into just getting the plays on in time. The risk in any creative activity is that you cannot predict the outcome, but we do promise you, from our experience of working on these plays with young people, that they – and you – will get something special from doing so. They're terrific pieces of writing,

and they really come to life in the performances of the young people for whom they were conceived.

I think the feeling of group success was the biggest achievement for our kids.

 Teacher directing in Unicorn Class Acts festival

More than sixty years ago, the Unicorn's founder Caryl Jenner created a company which dedicated itself to responding to the creative needs of young people as audience members, first touring in a succession of unwieldy vehicles, then squatting defiantly in the middle of London's West End while campaigning for a permanent home. In December 2005, with the opening of a beautiful, award-winning new theatre building, a new phase in our history began.

We don't only stage professional theatre performances by the Unicorn company and visitors from this country and abroad, which aim to delight, excite and inspire audience members of all ages. We also have a year-round programme of participatory work, in which young people's practical creative development takes place through schools and family workshops, youth theatres and our Young Company. The same values drive both strands of our activity: expanding access, leading with art and imagination, being truthful and – as we've already said, aiming to transcend and transform.

Superficially, there is a world of difference between a highly trained professional team performing to a paying public audience and the nightmare vision of the school play from hell. Plotless pageants in which scene endlessly follows scene with no apparent end in sight. The class 'stars' declaiming pages of text while twenty-five supernumeraries grudgingly playing trees or Oompa Loompas relentlessly upstage them, by accident or design. Surreal concoctions of playground-perfected bump and grind dance routines inserted into biblical narratives... Often excruciating, inadvertently hilarious and exhausting for participant and audience alike – but probably still highly significant. Because the act of making theatre together, even really bad theatre, taps into something that makes immense demands on those notorious 'multiple intelligences'. It's linguistic, interper-

sonal, kinaesthetic, spatial, emotional, usually musical – and if you want mathematical, just start measuring up the set and costumes.

> *All children start their school careers with sparkling imaginations, fertile minds, and a willingness to take risks with what they think... Most students never get to explore the full range of their abilities and interests.*
>
> from 'The Element' by Ken Robinson with
> Lou Aronica

Even doing a really terrible play at the end of your Primary School career or holiday playscheme can be exhilarating. What we wanted to do with Class Acts was offer material to make that experience more rewarding.

We were inspired by the National Theatre's Connections project, which has over the last fifteen years commissioned scores of new plays specifically for youth theatre performance. We got terrific advice and support from Suzy Graham-Adriani and Anthony Banks from the National Theatre as we planned and developed Class Acts.

Like the National Theatre, we approached the best playwrights we could think of for the job. Oladipo Agboluaje, Lin Coghlan and Philip Osment are all writers whose work we knew and greatly admired. Although highly respected for their work in different media, we knew that they shared our belief that creating work for children to act would demand the best they could do. At this point, however, we hadn't realised quite what a tough challenge we would be setting them!

When we commission plays for the Unicorn, we want the writer to tell a story, create characters or investigate themes about which she or he is passionate. The Class Acts commission was completely open in terms of subject matter, as you can see from the diversity of the plays. *Of the Terrifying Events on the Hamelin Estate* takes a classic story – *The Pied Piper of Hamelin*, well known from Robert Browning's nineteenth century poem – and transplants it to a modern urban setting. *The Acme Thunderer* takes place during the bombing of London during the Second World War and took specific inspiration from the East

End streets around the school whose class was to premiere the play. *The Wish Collector* ranges in time and space, exploring the links between the lives of two children in different continents and facing different pressures: fighting in the streets and fields and in the family. Philip Osment's play is in verse with a strong contemporary tang, Lin Coghlan's engages with the vocabulary of its performers' grandparents' and great-grandparents' generations; and Oladipo Agboluaje's moves between naturalistic dialogue and epic storytelling. They couldn't have been more different if we'd told them they had to be.

So much for creative freedom. Then came the constraints. It had to be a short play, in part because less is always more and we felt a well-rehearsed twenty to thirty minutes would be more appreciated by everyone than a thinly prepared hour. And we were planning to present all three plays at the Unicorn in a single performance, which, even allowing for optimistic turn-around time between plays, risked stretching to Wagnerian lengths. So the writers needed to tell their brilliant stories with the brevity of a single television episode. If a good new stage play comes in at an hour and a half it's considered a master-piece of concision. We expected our writers to get all three stories polished off in under that time.

It was all a bit Goldilocks-like when the first drafts arrived – one was a little baby package of pages, one felt just right already, and another was a great big Parent Bear of a thing – brilliant but huge. Which wasn't surprising given our other stipulation – we wanted each play to suit a cast of thirty – that being as you know the size that (for reasons we don't claim to fathom) the government feels works ideally for a primary school class. If these were to be truly Class Acts, everyone needed a role.

> *They actually got to the point where it stopped being about my role and started to be about our play. For them to realise that actually if we don't help [one of the children] do his part, our play might suffer and it became their play…a big group play. They came out after the first performance and children that I've never seen talk to each other before went up and hugged each other saying 'God you were amazing…' It sounds like*

*such a tiny little thing, but for the group of kids that were
doing it with me, that's huge!*

Teacher from Class Acts

We knew there would be larger and smaller roles, reflecting the range of skills and inclinations in any class. But in contemporary theatre commissioning, a cast of *eight* is epic. Outside West End musicals, only the National Theatre and the Royal Shakespeare Company have the resources regularly to ask writers for plays where there are more performers than words in the title. It's a thrilling challenge – and one of the reasons why Class Acts, like National Connections, had no trouble persuading playwrights to take it on. But it's a challenge nevertheless – and those of you using your mathematical intelligence will have worked out that thirty actors in as many minutes means squeezing a lot in.

All the plays therefore feature variations on choral and large group scenes. Each writer's use of that element is distinctive, but the chorus is in all three integral to the drama. In *Of the Terrifying Events…* it literally tells us a lot of the story. In *The Acme Thunderer* it provides the sense of location in time and space amid which the children's stories unfold. And in *The Wish Collector* it's as if the chorus spills out of the imaginary worlds of the play to stand in for all of us – the audience whose silent wishes bubble up and around alongside those expressed by the performers.

You *could* explore with your cast the ways in which the chorus as a dramatic device has endured: setting scenes, commenting on action, sounding voices of conformity or opposition, from classical Greek to contemporary epic theatre, from the spectacle of grand opera to the intensity of postmodern performance art. But you'll probably be busy enough sharing out the roles and working out where they stand. Dramatically, the chorus creates a powerful collective voice and presence. It is great as a way to involve children who feel self-conscious exposed as individual performers, with the potential to be very much more than the sum of its individual parts. Its vocal, physical, musical, sculptural qualities are whatever each different group makes of them.

*I had children who had hardly said anything publicly over
the course of the whole year who suddenly found their voices
through the play.*

*The head teacher said 'I never even noticed half these
children in our school and there they are leading this play with
really big parts.'*

Teachers from Class Acts

From reality television we have learned that the first step in putting on a show is a hard-core audition process: solo 'turns' before intimidating panels ruthlessly weeding out the Idol from the Extras. One big piece of advice you'll find in the resources below is not to do that. Explore the play with the class trying out different roles with different performers. Allow them to surprise you and themselves. Someone who gives a terrible first reading can turn out to have a wonderful presence on stage when not anxious about following a script. A couple of big personalities can transform your chorus from an afterthought into a show-stopping delight.

On top of stipulations on length and cast size there was another core demand we made of our long-suffering writers. The plays had to be performable almost *anywhere*. You can't rely on a swinging chandelier or a flying car to provide drama – it has to be in the writing. You can't assume there will be extravagant settings to do the work of telling the audience where they are – you need to create the place and time in the play itself. Philip Osment does that with lyrical storytelling, Lin Coghlan through attention to the detail of the objects and environmental features which evoke wartime London, and Oladipo Agboluaje switches continents with panache using techniques of 'cutting' between scenes. The montage effect is part of the unconscious dramatic grammar for any generation brought up with stories told on screen (and for that reason, *The Wish Collector* – indeed all the plays – should flow directly between scenes: no blackouts).

The Class Acts plays can be performed anywhere your audience is able to see and hear: on the best equipped modern stage, but also in any type of school hall. If it's a place you can do a good assembly, then these plays can work there. A modestly equipped hall can enhance the plays with simple lighting and

sound. But there is also something magical about transforming a familiar environment, one which can be decorated with examples with the work children have done in investigating and creating the world of the play.

Work on these plays, like any school production, can extend beyond the classroom. The play can involve family members and carers in many different ways. Learning text provides opportunities for reading, speaking and listening together. Calls can go out for materials to create props and costumes – offerings that can themselves have a story: an old hat, a West African fabric… Although the plays have emotional, intellectual and imaginative depth, we always hoped that the experience of producing them would be a celebration for the casts and their communities.

There is no 'right' way to produce these plays. If they and their actors are treated with integrity and a genuine spirit of exploration, we are confident they can come to life in many different ways. One of the Unicorn's great friends was the poet Adrian Mitchell, who argued that there should be a children's theatre in every town and city. That may not have happened yet, but we hope that by publishing these plays and encouraging their production, a little bit of Unicorn can appear wherever you are. Class Acts is a project which has had a permanent impact on the way we make theatre, and we know it has had lasting effects on the children and the teachers involved. We hope it will offer something just as rich to you. Good luck!

> *They were very proud that all their lines were learned, that they looked good. And they felt good.*
>
> Teacher from Class Acts

Carl Miller
Associate Director (Literary) of Unicorn

MAKING CLASS ACTS:
Teachers' Resources

The three plays in this book were originally written to be performed by one class of up to thirty Year 6 pupils. Whether you perform the play as an end of term assembly or decide to put on a full scale production as the Year 6 production, here are some ideas for exploring the play with a group of children and shaping your play ready for performance.

> *The teachers that came, I'm not sure that they actually expected the kids to pull it off. Everybody went back with a new attitude that if the kids that did it last year from our school could do it, then any kids from our school could do it. It changed everybody's view of doing drama with our kids.*
>
> Teacher from Class Acts

Unicorn Artistic Director Tony Graham on directing:

'The first thing I learnt about directing is to really believe in the play. Start by finding something in the play with which you personally connect. It might not be the most important thing in the play, but it's a starting-point, a way in. Maybe it's a character you recognise – not necessarily the main character. Or it might be a familiar dilemma. Or it could be the place or context in which the play is set, the world of the play. From this perspective, it's now possible to begin.

'Directing a play is in many ways akin to the best teaching. We want to share some questions with our actors and, above all, our audiences. Our job is not to provide the answers. Some things in a play are less important than others. It's the job of the director to work out what we need to focus on.

'We can learn a lot about a play by working on it from the inside. What we thought when we read it or at the beginning of rehearsals is not necessarily the same as we discover by the end. We must be prepared to change our minds. And it's not until we see the play stood on its feet with an audience before it that we truly begin to see what is there.

'Try to be playful with your actors – especially with serious material. The more the performers can free up their imaginations, the more physically they explore the material, the more adventurous they can be in rehearsal… the greater is the chance that the audience will enjoy the experience too. Singing can be liberating – and a great way of warming up a group – even if there are no songs in the play. Physical exercises too – for example running on the spot, freezing, instant pictures.

'Ultimately, we want to create something that will shake, rattle and roll our audiences. It's all about finding the emotional heart of the play – the thing that moves us.'

Beginning with your class

Reading the play with a group of children for the first time is an exciting moment: finding out what the children think it's about, what questions they have and what they enjoy and relate to in the play can all be captured after the first reading.

Give out parts for the first read-through but say that you will not be casting until the whole class or group have explored the play together. Doing a few sessions where you explore what the play means and what interests you as a class will be beneficial. When you do come to casting you will have had the opportunity to see children taking on different roles and in different combinations. Teachers are often surprised by children in their class seeing new things during this process of exploration, and go on to cast against their initial instincts.

Freeze frames

This is a useful way of finding out what the children think the play is about and what interests them most about the play.

Having read the play through as a whole class, break into small groups and give each group the task of telling the story of the whole play using five frozen images. They will need to discuss and negotiate what the key moments in the play are. When they have created their five images they can then give each image a title.

Now share the work, acting as audience for each other. You as director may want to read the title for each image, or alternatively the group can do this for themselves.

You will get a strong sense of what the children understand at this early stage. What makes sense to them and where do their questions lie? You will also see what the play means to them, what they care about in the piece. The class can then discuss:

- What they think the play is about;
- What the most important things are for an audience to understand;
- Where the moments of dramatic action lie;
- How the characters relate to each other and why.

Using freeze frames in rehearsal

The freeze frame technique can also be useful when trying to rehearse scenes as a way of building the action. Children will find the freeze frame a useful way of distilling what they want to show in the scene and making decisions about character and action.

- Create an image at the beginning of the scene and then an image for how you think the scene might end.
- You can now improvise what happens between these two moments.

Group work and staging

One of the main challenges of these plays is the large cast and the need to create pictures on the stage using large groups. Chorus work where children speak, sing or move together can be very useful in creating a dynamic staging of your piece.

These exercises are good for working on collaboration and group focus. It will also help children with fewer lines understand how crucial they are in telling the story.

Mirroring

- Start with children in pairs. Ask them to label themselves A and B.

- Ask A to be the leader and B to mirror as closely as possible what A does.

Both children are responsible for the activity: A's must ensure that they are moving at a pace that B's can follow, while B has to observe very carefully what A is doing.

If you want to explore atmosphere, mood and pace you could add some music and see how that affects how the children move.

Ask half of the class to watch as the other half does the mirroring. Ask the audience to comment on what is interesting to watch.

Chorus work – flocking

When the group are working well with mirroring you can move on to larger groups moving and speaking together.

- Ask a group of children to stand together in formation, creating the point of an arrow or a triangular shape with one person at the front, two on the next row and so on.
- Stand with your hand up in front of them and ask them all to focus on your hand as a point of unified focus.
- As you move your hand slowly backwards, forwards and side to side, ask the group to follow your hand, always keeping the same distance from it, rather like they are following a conductor's baton.
- When you have managed this exercise on the spot start to move, travelling around the hall together.

Begin this exercise slowly: the aim is for the group to work in unison so you need to find the best way for them to achieve this. When they are working well together as a group begin experimenting with pace.

- Freeze the group at certain points.
- Now add speech. Give the group a phrase from the script. Every time you close your hand they are to say the phrase together.

Get the group to explore saying the phrase in different ways whilst the movement of your hand determines the pace and power of movement they make.

Different vocal instructions could include: whisper, shout, say it mysteriously, with anger, secretly, sounding surprised, disgusted, sad or upset, chanting as at a football crowd or as if at a very posh party.

Character work

Having worked on the play together as a group at some point you will need to cast. At this point children will start thinking more about their individual characters and finding their personal connection to that character.

For children who have smaller parts or are mainly in the chorus it will help them to create rounded characters. They could identify their back stories (what has happened to them before the play begins) through writing or visual art activities. They can consider their characters' motivations in any given moment: why do they want to tell us this story now – to shock us, entertain us, make us understand how they feel?

Creating character outlines

This can be done as an individual activity or the whole class/group can work together to develop their understanding of a key character in the play: for example the Wish Collector or the Pied Piper.

- Draw an outline of a body (if working as a whole class get large paper and draw round a volunteer).
- Around the *outside* of the outline of the body write in all the facts about the character that you know from the play.
- *Inside* the outline, write what you think is on the inside of the character that may be hidden from others, or what you don't know about your character that you'd like to find out during rehearsals.

To extend this activity you could also focus on the head and heart to explore the character's thoughts and feelings.

HEAD – I think…because

HEART – I feel…because

Keeping records

The job of the director is to bring the elements together as a coherent whole, so while you are exploring the play and generating lots of material try and record the strongest ideas. You can then return to them when you finally start piecing your play together. A digital camera or pen and paper are all useful ways of documenting the process.

Using your skills

As Tony Graham says above: 'Directing a play is in many ways akin to the best teaching.' Many of the activities here can feed into classroom work outside the play (the speaking and listening objectives at Key Stage 2, for example). Teachers with whom we have worked at Unicorn have often gone on to use the activities within their classroom teaching.

Activities with a class outside a drama context can also be part of preparing the play. Your interests and talents in working with the group will also be valuable in creating a production which has depth and lasting value.

> *It was something that we were able to build in with visits to the Imperial War Museum, and talk about, and it linked with history topics so we were able to do work around it... I built in a couple of weeks of literacy work based on the actual words and could have easily spent six weeks looking at underlying feelings, thoughts and characters, but we did a lot of that in the drama as well so that was quite nicely balanced.*
>
> Teacher from Class Acts

Cath Greenwood
Education and Youth Director of Unicorn

These activities are a small selection taken from our Class Acts Teachers' Resource Pack. Contributors to this pack were: Andy Brereton, Vernon Douglas, Cath Greenwood, Sharon Aviva Jones, Jess Layton, Jenny Maddox and Fiona Whitelaw.

If you would like a copy of the full resource pack please contact the Unicorn Education Department on education@unicorntheatre.com

THE UNICORN THEATRE

The Unicorn Theatre is one of the leading producers of professional theatre for children and young people in the UK. Its award-winning home on the south bank of the Thames is the only purpose-built theatre for young people in London. As a major venue in the city's glittering Cultural Quarter, it has developed a reputation as a national centre for children's culture. The Unicorn is a beacon for the best Young Theatre for all ages.

Its own award-winning programme of new and classic plays is accompanied by a highly-regarded Learning and Participatory programme that is integral to the life of the company. The Unicorn hosts the highest-quality visiting national and international theatre for children. Internationalism, new writing, innovation in form and content, participation: these are the company's major inspirations. A year-round acting ensemble animates all spheres of the company's busy life from acting to education to development. The Unicorn provides access to the arts for all children and young people, regardless of age, ability, or culture.

Opened in December 2005, the Unicorn houses the Weston Theatre (a flexible thrust stage with an audience capacity of 300), the Clore Theatre (a flexible black box studio with an audience capacity of 100), the Foyle Studio (for education), the Judi Dench rehearsal room, a café and other welcoming areas for families and schools. The theatre company was founded in 1947 by Caryl Jenner, whose unique vision and inspiration made the building of this flagship theatre possible.

Unicorn Theatre
147 Tooley Street
London
SE1 2HZ

Admin: 020 7645 0500
Box Office: 020 7645 0560
www.unicorntheatre.com

CLASS ACTS PRODUCTION TEAM 2008

Education and Youth Director	Cath Greenwood
Class Acts Project Manager	Jenny Maddox

Jess Layton was Class Acts Project Manager during the first stages and pilot festival of Class Acts, and was involved in the commissioning of these three plays.

Director/Facilitators	Sharon Aviva Jones & Fiona Whitelaw
Set Design & Support	Laura McEwen
Dramaturg	Carl Miller
Master of Ceremonies	Duncan Duff
Production Manager	Adam Carrée
Stage Manager	Emma Basilico
Assistant Stage Manager	Marie Maton
Production Photographs	Lisa Barnard
Senior Technician	Keith Edgehill
Technician	Adam Clegg
Set Build and Painting	Jef Mitchell
Aerial Rigging & Technician	John 'Buttercup' Ryan
Soft furnishings & additional props	Mark Jones
Production Work Experience	Sasha Glenny, Meg Evans
Support Volunteers	Katherine Craft, Ragnhild Myntevik, Lookman Sanusi, Emma Higham, Alicia McKenzie, Charles Anthony Taylor

UNICORN STAFF

Artistic Director	Tony Graham
Associate Artistic Director	Rosamunde Hutt
Associate Director (Literary)	Carl Miller
Assistant to the Artistic Team	Ruth Weyman
General Manager	Alex McGowan
Finance Director	Christopher Moxon
Planning & Operations Director	Andy Shewan

Finance & Education Assistant	Alicia McKenzie
Development Director	Sioban Whitney-Low
Development Manager	Dorcas Morgan
Development & Access Manager	Kate Hladky
Development Assistant	Hayley Pulford
Education & Youth Director	Catherine Greenwood
Education Manager	Jenny Maddox
Youth Programme Manager	Emma Higham
Marketing Manager	Elliot Rose
Marketing Officer	Sara Coffey
Communications Officer	Rachel Stroud
Production Manager	Adam Carrée
Assistant Production Manager	Lisa Harmer
Senior Technicians	Keith Edgehill, Jef Mitchell
Technician	Adam Clegg
Wardrobe Supervisor	Mark Jones
Theatre Manager	Carolyn Forsyth
Deputy Theatre Manager	Zuleika Scott
Stage Door Administrator	Sair Smith
Part-Time Stage Door Keeper	Simon Wegrzyn
Box Office Manager	Samantha Whates
Ensemble Company	Samantha Adams, John Cockerill, Julie Hewlett, Amit Sharma, David Smith, Gehane Strehler

Unicorn Theatre is grateful to the John L Beckwith Charitable settlement for helping us establish the Class Acts festival and for supporting the commission of these three plays.

Class Acts is currently supported by HSBC Global Education Trust, John Lyon's Charity and by Bloomberg through their 'Discovering Theatre' programme.

Unicorn Theatre funded by

 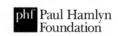

The
McGrath
Trust

THE WISH COLLECTOR
Oladipo Agboluaje

OLADIPO AGBOLUAJE

Plays include: *Early Morning* (Futuretense/Oval House), *Mother Courage and her Children* (adaptation, Eclipse Theatre, national tour), *The Estate* (Tiata Fahodzi), *God is a DJ, Knock Against My Heart* (Theatre Centre), *For One Night Only* (PBAB), *British-ish* (New Wolsey Youth Theatre), *Captain Britain* (New Wolsey/Talawa), *The Christ of Coldharbour Lane* (Soho Theatre), *The Hounding of David Oluwale* (adaptation, Eclipse Theatre, national tour), *Iya-Ile – The First Wife* (Tiata Fahodzi, Soho Theatre).

Oladipo is adapting *The Estate* as a feature film for Heyman Hoskins and the UK Film Council. He is also writing a feature adapted from his short film *Area Boys* with Director Mel Mwanguma for Focus Features.

Characters

WISH COLLECTOR
CHILDREN
CHILD 1
CHILD 2
CHILD 3
CHILD 4
CHILD 5
CHILD 6
CHILD 7
CHILD 8
THE CHORUS
SAM
SAM'S MUM
SAM'S DAD
SAM'S TEACHER
CHRIS
FRIEND
ESSIE
PATIENCE
ESSIE'S FATHER
ESSIE'S MOTHER
MRS DANIELS
ERIC
TROOP OF SOLDIERS
COMMANDER

The Wish Collector was first performed by Hill Mead Primary School, Lambeth at the Unicorn Theatre, on 9 July 2008, with the following cast:

Naomi Adeboye, Lynda Adewoye, Kehinde Afolabi, Halima Ali, Hussein Ali, Symeon Anderson, Sabrina Boateng, Latario Brown, Cristiana Coelho, Shanice Coombs, Montana Dume-Gooden, Grace Durojaiye, Rukevwe Eyeregba, Kevan Jackson, Joseph Latorre Cragg, Folayemi Olatunde-Adeyemo, Ridwaan Shergow, Ade Shitta, Precious Shogbeni, Ajmal Zadran

Director Christina Huszar

Unicorn Facilitator Sharon Aviva Jones

CHILDREN playing, studying, eating, listening to music, mucking about, etc. They have ribbons attached to their collars. The ribbons represent their wishes. The CHILDREN will become the CHORUS.

CHILDREN: (*Sing.*) 'I wish', 'I wish',
Are two favourite words of mine
'I wish', 'I wish'
I say each and every time
When I'm wide awake
When I'm fast asleep
And lost deep in my dreams
'I wish', 'I wish'
That my wishes will come true.

WISH COLLECTOR dashes in.

WC: I'm the Wish Collector, get out my way!
I'm on the clock, I can't delay
I'm here to take your wishes away
So keep on wishing, make my day!

WISH COLLECTOR takes the wishes away from the CHILDREN as they make their wishes.

CHILD 1: I wish I could bend it like Beckham.

CHILD 2: I wish I could be a queen.

CHILD 3: If only there'd be no more housework.

CHILD 4: I wish I'd only have sweet dreams.

CHILD 5: I wish to eat only plantains.

CHILD 6: Give me crisps any time of the day.

CHILD 7: For once can my stomach stop rumbling?

CHILD 8: Will this pain ever go away?

ALL: 'I wish', 'I wish'
That my wishes would come true
For just one day
And I promise I'll be good.

WC: Don't stop, keep on wishing
There's a full moon coming.

(*To the audience.*) They'll be all right. You don't believe me? You know when you have these wishes like fifty times a day and not all of them will come true and some you'll forget and you'll have new ones and some you grow out of? Well, I make that wheel inside your head keep turning with new wishes by taking away the old wishes. That's my job and I'm good at it. Why?

> Because I'm unsentimental
> I know I look so gentle
> Believe: that's not a tear in my eye
> I do the job I have to
> Even wishes that are enough to
> Bring tears from every cloud in the sky.

> So come on!
> No wish is too big, no wish is too small
> My bag is big enough to take them all.
> I need to get back soon
> To give them to the full moon.

CHORUS: That's not fair.
That's not right.
They're our wishes.
You've no right.

WC: Hey, some of your wishes come true. (*Approaches one.*) Didn't your Dad get you that dress for your birthday? And you, the cost of rice came down, didn't it?

CHILD 1: But it doubled the next day/

WC: And you, when was the last time you had any homework? Eh?

CHILD 2: That was because the monsoon washed away my school.

WC: You ungrateful lot, I could stop you all from having wishes, let you lead dull lives with nothing to look forward to. Maybe you'd like that?

The CHORUS steps back.

I didn't think so.

CHORUS: You're very harsh!

WC: Me, harsh? You're having a laugh. Now I'd love to chat but this is only a stop on my way around the world.

The CHORUS surrounds him.

I don't believe this. Will you kindly get out of my way?

The CHORUS does not budge.

(*Warns.*) Once I say the magic words you'll never wish again!

CHORUS: If you do that you won't have enough wishes to give to the moon.

WC: You're not the only children in the world, wise guy.

CHORUS: Please let us keep our wishes.

WC: No.

CHORUS: Why?

WC: Because.

CHORUS: Because what?

WC: Because move!

CHORUS: What's a childhood
 If I can't keep wishes?
 With what do I build my dreams?
 How do I face this dreary world
 Without imagination,
 Without great expectations?
 What do I hope for tomorrow?

WC: (*Pretends to cry, then.*) Look! They're not for me. They're for the moon.

CHORUS: What does the moon want with our wishes?

WC: You don't understand.

CHORUS: Then I'll make a wish to the moon. Moon, I wish/

WC: Don't!

CHORUS: Why not?

WC: Just don't.

CHORUS: If you don't tell us we'll all make wishes to the moon. (*They face the moon.*) Moon, Moon/

WC: Okay! Okay. It was a long time ago. I made a wish to the moon that I wanted to live forever and the moon said 'I'll grant your wish but you must collect wishes from children until I shine brighter than the sun and then I'll let you go.' So. I need a few more wishes and then I'm done. Then you can wish all you like because I'll never bother you again.

CHORUS: You're selfish. Your dream's come true so why can't mine?

WC: It's a long story. I'll tell you when I finish. But first I've got wishes to catch! Now let's see…

The CHORUS disassembles to reveal SAM, playing 'Lunar Wars' on his console. The CHORUS becomes characters in his game. ESSIE is a character in the game.

SAM: Shoot-em-up, RPG
 Upgrade weapon
 Level three
 Watch me race
 Into battle
 Power up
 Win the game
 Online fame
 Restart game

The CHORUS continues playing the characters.

I'm playing 'Lunar Wars'. Win a battle and your moon waxes brighter. I'm the best in my class. 'Lunar Wars 2' is just out. Mum's promised to get it for me if my grades improve. Dad promised he'd buy me a Game Player. Mum said he wouldn't because he's so stingy. Dad called Mum a nag. Then we all laughed. I wish no one gets them before I do. Got to keep my crown in the playground, you know. Now if I can just reach Level Ten one more time…

WISH COLLECTOR takes the wish off SAM. The moon brightens.

GAME: 'Game over'.

SAM: (*Jumps up in frustration.*) Oh! Nearly, nearly.

GAME: 'Restart game'.

SAM: For days I'd get lost in a world of battles and heroes. That must have been when it started.

The sound of SAM's MUM and DAD arguing. WC and the CHORUS cover their ears.

They argue all the time now. I don't know why. I wish they'd stop. (*Continues playing.*)

WC takes SAM's wish away. The moon brightens. African music starts playing. We are in Sierra Leone with ESSIE. She is in her school uniform. The CHORUS dances African-style. They get WC to join in. ESSIE is in her garden.

ESSIE: My garden. I look after my flowers every morning before I go to school, and in the evening when I return. Today is a special day for me. My uncle who lives in Accra promised to send me a Game Player! I still think I'm dreaming. Every day I wait for Father to come home from the post office with a box behind his back saying, 'Essie, guess what I've got for you.'

PATIENCE: Essie!

ESSIE: Yes Father!… Oh. It's Patience. She's my friend. What's wrong?

PATIENCE: Has it come?

ESSIE: No, not yet.

PATIENCE: Oh! I was hoping we could play it before school.

ESSIE: Maybe my father will bring it with today's post. What do you think of my beautiful flowers?

PATIENCE: You and your garden. Come on! We'll be late for school. (*Hands ESSIE her bag.*)

ESSIE: I will spend all day dreaming of the Game Player and the games that will come with it.

Back in London. The CHORUS forms a classroom. SAM is asleep. WC sits down. A CHORUS member throws a ball of paper at him.

WC: (*Stands up.*) Who did that? When I catch you, you're going to wish…

The CHORUS leans forward to hear the wish. WC sits down. TEACHER talks to SAM's MUM.

TEACHER: Sam's been sleeping in class.

SAM'S MUM: He spends too much time on his game, that's all.

TEACHER: He's been doing so well. I wish he'd continue.

WC collects TEACHER's wish. The moon brightens. The bell rings for break. SAM wakes up.

School playground. SAM is playing with a mate at 'Lunar Wars'.

SAM: The playground! Where I am king. (*Beats his classmate.*) Next!

CHORUS:
 Sam, Sam king of the playground
 Beware, friend or foe
 Sam's in control
 On his handheld console
 He puts us all to shame
 What's his name?
 Sam, Sam, Sam, Sam, Sam…

CHRIS: (*A classmate.*) I'll play you.

The CHORUS flock to CHRIS.

SAM: Chris. He thinks he can beat me. Two-player mode. Best of three.

CHRIS brings out a new Game Player.

CHORUS: Wow! It's the new Game Player!

CHRIS: And not only that. (*Whips out 'Lunar Wars 2'.*) I've got...

CHORUS: 'Lunar Wars 2'!

CHRIS: What do you say Sam?

SAM: I'll still beat you, new game and all.

They play. CHRIS wins the first round.

I'm just warming up.

SAM wins the second.

Told you!

CHRIS wins the third game.

The CHORUS flock to CHRIS, chanting his name. CHRIS laughs at SAM.

CHORUS: Chris the champion, King of the playground...

SAM: I'm getting a new Game Player soon! Once Dad and Mum stop arguing I'll... Come on, it's Sam, Sam, Sam, Sam...

WC shakes his head.

The CHORUS disappears, leaving SAM back at home. He drops his schoolbag and picks up his Game Player. He plays furiously at his game.

SAM: I don't care if he's got a new Game Player or not. Chris is not taking my crown!

Door slams.

SAM: That's Dad out the door. If I'm lucky I might get an hour's nap before he comes back. It takes me a while to fall asleep. I start thinking, what if he never came back?… (*Falls asleep.*)

ESSIE runs in to find her FATHER waiting for her with his hands behind his back. MOTHER is making a dress.

ESSIE: Is it? Is it?

FATHER: Is it what?

ESSIE: Father please!

FATHER hands over the console. ESSIE hugs FATHER. She takes out the game and starts playing.

ESSIE: 'Little Minnie'! This is the game I wanted! You look after 'Little Minnie' on her fun adventures and she collects little circles that look just like the moon/

MOTHER: Go and eat your dinner!

ESSIE: I like this material. The flowers are just like the ones in my garden. Who is it for?

MRS DANIELS enters.

MRS DANIELS: It's for me. I'm wearing it to my sister's wedding.

ESSIE: Hello Mrs Daniels.

MRS DANIELS: Is my dress ready?

MOTHER: Not yet. Essie will bring it to you when I've finished.

ESSIE: Mrs Daniels, can I come with you to the wedding? I'll bring fresh flowers for the bride.

MOTHER: Essie!

MRS DANIELS: (*Laughs.*) If your Mother says yes.

ESSIE looks at MOTHER imploringly.

MOTHER: Do your homework and then we'll see.

ESSIE hugs MOTHER.

I didn't say yes.

MRS DANIELS: Make a wish to the full moon, just to be sure.

WC looks in horror, waving to ESSIE not to make a wish to the moon.

MOTHER: You don't believe in that old wives' tale?

MRS DANIELS and MOTHER argue.

ESSIE: Mother's always like that. She pretends she's strict but she'll let me go. Because she always grants me my wishes. Well, most of them.

WC is about to take the wish off her when he is taken away by the smell of food. ESSIE dresses for the party.

The CHORUS becomes the party.

The wedding party. People dancing, playing games. ESSIE marvels at the dresses that are worn and at the food being served.

What did I tell you? Food and drink, and beautiful dresses! There's Patience, playing the bossy Mama as usual. Eric's here! Has he noticed me?

Whenever ERIC looks at her, she turns away. Whenever ESSIE looks at ERIC, he turns away. They both look shy. Finally ERIC summons up the courage and goes over to her.

He doesn't like me. I wish... (*Sees him.*) Oh no, he's coming over! He's not, is he? He is!

ERIC: ... Hi.

ESSIE: (*Quickly.*) Hi. (*She winces at her quick reply.*)

ERIC: How are you?

ESSIE: Fine. How are you?

ERIC: Fine.

Embarrassing pause.

ESSIE: (*Blurts.*) I have a Game Player! Kai! Did I just say that? Ground, open up and swallow me.

WC quickly takes the wish away from her, careful that the ground doesn't open up.

ERIC: You do? Wow. I wish I had one.

WC collects the wish from ERIC. The moon brightens.

Can I come round your house and play with it sometimes?

ESSIE: Is he asking? Yes! I mean... yes. He smiles. I smile.

A song is played.

ERIC: That's my favourite song!

ESSIE: That's my favourite song too. It isn't but...

ERIC: Shall we...?

ESSIE: We go to the dance floor and we dance and dance and dance.

ALL: (*Sing.*) Celebrations, jubilation
 On this glorious day
 May the wishes of everybody
 Come true in their own way.

WC sings along, dancing and takes away all their wishes. By the end of the song he is exhausted. The moon waxes.

ESSIE: I wish this day will never end!

WC takes her wish away. He is given a plate of food. He is about to dig in when the CHORUS drags him to SAM's room.

SAM is in his room, playing his game. The CHORUS becomes the characters. ESSIE is the main character.

SAM: What I like about 'Lunar Wars' is that you can start all over again. Fail and just press 'restart'. You're always in control even though you haven't got the latest Game Player and some nerd called Chris is stealing your crown!

MUM enters. She puts a plate of food in front of him and leaves.

We used to sit at the table for dinner. That was in the good old days before I reached Level Ten.

Flashback: The good old days. SAM with MUM and DAD.

MUM: It's my turn to choose.

SAM: It's my turn!

MUM: You two always choose action films.

DAD: Because we're not into sob stories, are we Sam?

SAM: No, Dad. Dad's right. I hate sob stories.

> *DAD tosses a coin.*

> *The CHORUS toss a coin too.*

DAD: Call.

MUM: I'm not calling anything. It's my turn/

SAM: Heads!

DAD: Heads it is.

MUM: I was going to say heads! That's not fair.

DAD: What are you watching, son?

> *WC takes the wish from SAM's head. The moon waxes.*

> *The cinema. The CHORUS forms the audience members, and if possible they can play the actors in the movie.*

> *SAM, DAD and MUM watching the movie. MUM is engaged by it. DAD yawns with boredom. SAM is on his Game Player.*

SAM: 'Captain Crusher' was sold out. So we're watching Mum's film… Did it!

WC: (*Concentrating on the movie.*) Sh!

> *DAD extends his arm. SAM unwillingly hands over the Game Player.*

SAM: (*Whispers.*) I reached Level Ten! When are you getting me the new Game Player?

DAD: Sh!

SAM: I might as well watch this dumb movie…

Minutes later. SAM, DAD, MUM and the CHORUS are passing tissue round, weeping at the movie. WISH COLLECTOR also weeps. SAM passes the tissue to him.

SAM and his parents come out of the cinema.

MUM: See? You liked it.

DAD: No I didn't!

SAM's friends, including CHRIS, come out of the other screen.

SAM: I did!

CHRIS: Sam?

SAM: Oh! Hi Chris.

CHRIS: You came out of Screen 2.

SAM: No.

FRIEND: Yes you did! Sam!

They laugh at him. DAD and MUM smile. SAM goes back to his room, playing his Game Player.

SAM: Those were the good days. I wish they'd come back.

WC collects the wish from SAM, as DAD leaves the house with a slam of the door. The moon waxes. We return to Sierra Leone.

The sound of gunfire. People running back and forth in fear and confusion. The CHORUS forms a troop of soldiers, moving in a circle. The circle of soldiers disperses to reveal ESSIE in military uniform. The soldiers relax and play with ESSIE's Game Player.

ESSIE: I never thought I would ever hold a gun. I'm a child. Our commander, he's only a few years older than me, he enjoys it. He says the only reason they didn't hurt me was because of the Game Player.

The soldiers stop playing and stand to attention.

I remember the first time we attacked a village. Since then I have never had a good night's sleep. All I have are bad

memories that burn me like fire. I wish I could escape from here.

WC takes the wish from her. The moon waxes.

COMMANDER: Attention!

ESSIE joins her comrades and stands to attention.

ESSIE: We must move quickly. Our enemies are coming. I wish I could see my Mother and my Father again. But I don't know where they are.

WISH COLLECTOR hovers over her. He does not take the wish from her.

(*She looks up.*) Mrs Daniels said if I make a wish to the full moon it will come true. Full Moon, I wish that all this madness would stop and things would go back to normal. Patience will boss me off to school. Mother will sew beautiful clothes. I'll plant lovely flowers in my garden.

COMMANDER: Enemy approaching. Take cover!

The soldiers dive for cover. ESSIE stays where she is looking up to the moon.

SAM's DAD enters SAM's bedroom. He has a suitcase with him. He puts the new Game Player on SAM's bed and exits with his suitcase just as SAM enters his bedroom. He sees the new Game Player.

SAM: It's the new Game Player! (*Plays with it with enthusiasm, oh-ing and ah-ing at the graphics and sound.*)

(*Stops playing. Looks up at the sky.*) I'd give up all the moons I've won if Dad comes back home. We'll all be happy like before. I'll go and see a romantic movie with them and we'll cry into our hankies. Dad will say 'I didn't cry', and Mum will say, 'Yes you did!' and she'll ask me, 'was your Dad blubbering like a baby?' And Dad will say, 'he couldn't see me. He was crying more than you.'

WC stands over SAM and ESSIE, poised to take their dreams away.

CHORUS: (*They all look to WC.*) Don't. Please.

WC: I just need these last wishes and then I'm free.

CHORUS: You can't.

WC: I've been at this for three hundred years and I'm tired. I want to be free.

CHORUS: We'll wish for you. Take ours.

WC: They wouldn't be real. You'd be making them up just to help Essie and Sam. They're no good to me. If you want my advice: be careful what you wish for, in case they come true, living the dream has its downside. It's not all fun and games.

CHORUS: But what would happen if the moon gets its wish and shines like the sun?

WC: I, I don't know.

WISH COLLECTOR looks between ESSIE and SAM.

But what would happen if their wishes came true?

WISH COLLECTOR turns to the moon.

I can't.

The moon turns orange.

Please don't be angry. I'll shine you until you shine as bright as the sun. But I can't do this any more.

CHORUS: But that means you'll be shining the moon forever.

WISH COLLECTOR opens his bag and empties the wishes. Ribbons of every colour litter the stage.

WC: Wishes of the world, back to sender!

The moon changes back to its normal colour. WISH COLLECTOR gets sucked away behind the moon.

Night. The CHORUS members, as children of the world, asleep in their beds, singing 'I Wish'.

WISH COLLECTOR appears from behind the moon with a cloth and begins to shine the moon.

THE END

THE ACME THUNDERER
Lin Coghlan

LIN COGHLAN

Lin Coghlan has written widely for film, theatre, radio and television. Her plays include *Waking and Apache Tears*, as well as *The Night Garden*, *Mercy*, *Kingfisher Blue* and *The Miracle*, all published by Oberon Books.

Characters

PAULI 7
ANIA 11 – His sister

PAT 10 – Their cousin
JENSON 12 – Her brother

SIMONE 11 – Ania's best friend, a writer
NEELY 11 – Simone's best friend

TOPPER + SAM
Members of a gang on the street, both 12

NESTER 9 – Topper's little brother

PETE – A pigeon
SPARKY – A ferret

THE CHORUS

MAUREEN SWEENY – Owner of Bruno and Fluffy
BENNY + WINKS 10 – Twins
FIREWATCH – Fire Warden
MR PEABODY
MRS PEABODY
LARRY ALPHONSO – 10
ETHEL ALPHONSO 8 – His sister
PETE THE POST – Postman
LIZZY FORD 16
MATTY BARBER 10 – An Astronomer
SWANS

*The play is set on a single night in London in
September 1940.*

The Acme Thunderer was first performed by Hermitage Primary School, Tower Hamlets at the Unicorn Theatre, on 9 July 2008, with the following cast:

> Masud Ahmed, Monsur Ahmed, Naim Ahmed, Akthar Rima, Imran Ali, Nahida Ali, Shahjahan Ali, Aanisha Begum, Layla Boukriss, Cassius Chrystie, Jazz Chrystie, Sebastian Coker, Robin Ferdous, Habiba Raihana, Bushra Hussain, Saquib Hussain, Tahmid Hussain, Naymul Islam, Thawhid Khan, Aniqa Rahman, Kadiza Rahman, Tahmidur Rahman, Maheer Shahriyar

Director Joanne Morgan

Unicorn Facilitator Fiona Whitelaw

SCENE 1

London. A summer's night in 1940. A back garden South of the River. Number 37 Beachmont Road, Lewisham.

The CHORUS look down on the air raid shelter. They are the citizens of the city, preparing for the night ahead, with rolled up bedding and torches and helmets and bird cages and kitbags.

MRS SWEENY: Here's our town…

FIREWATCH: Still standing…

BENNY: Here's our street…

WINKS: Our lane…

MR PEABODY: Here's the gardens…

MRS PEABODY: And the roses,

We planted them when
All the kids were small…

Now we wonder what will happen

MR PEABODY: What will happen…

ALL: To us all…

LARRY A: Here's the shop,

ETHEL: The butchers

LARRY: Here's the flats where
Alfie lives

ETHEL: Mrs Sweeny
gets her bones there

LARRY: Bones for Bruno
That's her dog

FIREWATCH: Blackouts up it you don't mind Mrs
Brocklehurst!

WINKS: Let's get sorted

47

BENNY: Time to go…

MRS PEABODY: Cheesy sandwich, flask of coffee

MRS SWEENY: Maybe just a little stout…

LIZZY FORD: Come on Alfie –
 Its nearly time for bed…

MRS SWEENY: Come on Fluffy
 get down from the shed…
 That's right, into your basket…

MR PEABODY: Time we all were
 safely
 underground

MRS PEABODY Remembering so long ago
 when we slept safe and sound.

ALL: In the old days
 Before the war.

ANIA, 11, is lying on a rough bunk bed in the Anderson shelter, reading a book.

PAULI, 7, appears in the doorway with a bundle under his arm. He climbs up on his bunk and starts to organise his things.

ANIA: Mum says count the candles.

PAULI: You count them why don't you?

ANIA: (*Never looking up from her book.*) I'm busy.

PAULI: We got seven. You know we got seven.

ANIA: (*Still reading.*) What if Aunt Mags went and took some? You know Aunt Mags steals things.

PAT appears in the doorway. About ten years old. She heard the last remark.

 (*Never taking her eyes from her book.*) Make yourself at home why don't ya?

PAT: Thanks, I will. Move up Pauli.

PAULI: Get off.

PAT: You're too small to have a bed all of your own.

PAULI: I don't share with girls. This bunk is for boys. Ania, tell her, this bed is a boy's bed.

A tall boy arrives in the doorway. He could be a big twelve or thirteen.

JENSON: Your mum says keep the noise down.

ANIA: Can we get something clear for just one minute?

JENSON starts unpacking his suitcase.

ANIA: This is our Anderson shelter and you're visitors.

PAT: Jenson's the oldest.

ANIA: I don't care how old he is…you're not walking around giving orders in here. You stick by the rules or you're out.

PAULI: We got loads of rules in here.

JENSON goes to the door of the shelter and looks out.

No muddy boots, no wiping your hands on the blankets and all farting got to be done out the door.

JENSON looks out from the door.

JENSON: Your Gran's digging again.

PAULI: She buries things in the garden.

ANIA: You know what secret's meant to mean Paul?

PAULI: It's not a secret from them. They're family.

ANIA:	Not proper family. His father is Mum's stepbrother, which means he's not really a blood relation at all.
PAULI:	She's hiding our special things in the garden – in case the Germans come.
ANIA:	You should have done that, shouldn't you?
PAT:	Didn't have time, did we?
ANIA:	If you'd buried money in your garden you wouldn't have had to come here and live off us.
	Beat.
PAT:	We didn't have time to do nothing when the bomb dropped. And Nipper run off and never come back.
	PAT sits miserably and stares ahead.
	I called and called but he didn't come.
	ANIA looks up from her book to JENSON in the doorway.
ANIA:	You going to stand there all night?
	He stands there.
	Suit yourself.
	PAT chucks all her stuff on the top bunk and suddenly comes face to face with something.
PAT:	Urgghhhh, what's this?
PAULI:	Pigeon. His name's Pete. I'm training him, to work for the Army Signals Corp.
JENSON:	Anyone hungry?
PAT:	Pauli's always hungry.
JENSON:	Just thought you might fancy some… Pigeon pie.

JENSON grabs the pigeon box, holds it above PAULI's head.

PAULI: Give it back. Give it to me.

JENSON: Taste lovely with a bit of dripping.

ANIA: Give it him back or I'll tell mum.

JENSON: You think I'm scared of your mum?

ANIA: (*Jumping down.*) You should be, one word and you're out on the street.

JENSON stands there the box in his hand way above PAULI's head. PAT looks on, nervous.

JENSON chucks the box at PAULI who catches it.

JENSON: You think I care about your stupid Pigeon.

PAULI takes the box protectively up to his bunk, soothing the pigeon.

PAT: I'm going to call Nipper again.

ANIA: (*Reading.*) He'll be long gone by now.

PAT: Could be hiding.

PAT goes to the door.

PAT: Nipper? Nips! Come here puss.

PAULI: I liked Nipper.

ANIA: You never even met him Paul.

PAULI: I still liked him.

A tall girl arrives in the doorway with a piece of bamboo which has a blanket rolled round it.

SIMONE: Mr Blackwell won't let me rehearse under our stairs. Say's he's got a headache. Who's this?

ANIA: Jenson.

PAULI:	His house got flattened and his dad's a conchie who's working on a farm with a llama that can spit really really hard.
SIMONE:	I see. Ania, you're going to have to be Edith Cavell.
ANIA:	You said I could be Florence Nightingale...

A girl appears in the doorway.

NEELY:	Look what I've got Simo. Three old sheets and a HUGE potty.

NEELY dumps her haul down. JENSON walks away.

We can make slings for the hospital
scene and Cleopatra can be on the potty
– Thinking.

SCENE 2
The Back Lane

JENSON is stopped by a gang of kids.

TOPPER:	Hold up.

JENSON stops.

Do I know you?

JENSON says nothing.

NESTER:	I got to go home. Mum said, it's late...
TOPPER:	You here with your dad? Oh sorry, I forgot, he'll be tucked up by now in the hen house, buk buk buk...

JENSON stakes a step forward but they block his way.

He's a conchie...isn't he?

Beat.

My brother got killed over there.

JENSON looks at him.

That's your fault the way I see it.

Suddenly the air raid warning goes. The kids stop in their tracks looking up at the sky.

WINKS: From Hampstead Heath
To One Tree Hill

BENNY: The city hunkers down

FIREWATCH: From the old Town Hall in Bromley
To the cellar of the Horse and Crown

MR PEABODY: From Commercial Road
To the Deptford Docks

MRS PEABODY: From the duck pond down the lane

PETE THE POST: We're hiding from the German aeroplanes
While the bombs fall down like rain

LARRY: The old folks sit underneath their stairs

ETHEL: 'We ain't going to sit in the garden'

LIZZY FORD: The young folks kiss in the underground

MRS PEABODY: And they don't even beg your pardon.

BENNY: We're the kids who sat
Every bloomin' night
And who wondered if they'd live or die

WINKS: Life was cheap then
Life was sweet then

ALL: As the searchlights filled the sky.

MATTY: (*Looking up.*) That's Cassiopeia that is. And up there's the North Star. You ever get lost, that's how you find you way home.

SCENE 3
The Anderson Shelter

SIMONE, NEELY, PAT and PAULI sit in the shelter.

ANIA comes in.

ANIA: Mum's gone to look for 'that woman'.

PAT: Mummy has to go out when there's an air raid ever since our house got hit.

ANIA: All I'm saying is 'normal' people shouldn't have to go chasing after her.

Silence.

PAULI's polishing something.

PAT: What you got in there?

PAULI: The Acme Thunderer. Daddy gave it to me, it's the best whistle in the country, probably the world.

PAULI suddenly sees the torch.

PAULI: Mum hasn't got her torch.

ANIA: Too late for that now Paul.

PAULI: (*Panicky.*) But she needs her torch, she NEEDS it.

ANIA: (*Distracting him.*) You can help us with the play Pauli, what do you want to be?

PAULI: A gnome...or a goblin...

ANIA: Alright then...

Bombs fall in the distance.

SCENE 4
Under the stairs six doors down

TOPPER, SAM, NESTER and JENSON sit on crates.

SAM's reading a comic with a torch. NESTER's knitting.

TOPPER lights a lantern.

TOPPER: Should have left you out there to get your head blown off.

SAM: I don't suppose he can help what his dad done.

TOPPER: That's where you're wrong. Runs in the blood, don't it? Being a traitor.

TOPPER hangs the lamp up.

JENSON sits, silent.

SAM looks through the hole in the wall into next door's cellar.

TOPPER: They in there?

SAM: It's the granddad…

TOPPER: (*Climbing up.*) We get hard evidence on him we could get a medal…

SAM drinks some more cocoa, hands it to JENSON, who drinks.

SAM: They send your dad to jail then?

TOPPER: (*Into the hole.*) Should've done…

JENSON: Sent him down the Arsenal making munitions…

SAM: Our Laura's down the Arsenal…

JENSON: But he asked to be moved.

SAM:	I'd top meself if my dad was a conchie. Don't he never think of no one but himself?

Suddenly TOPPER stumbles back off the box, holding his eye, he crashes into the others, who all grab weapons in a state of hysteria.

SAM:	What's happened…?
TOPPER:	Something come at me, nearly had me eye out…

A voice comes out of the hole.

VOICE:	Who's there?

The kids shut up.

MR PEABODY:	(*Through the hole.*) Sparky, you down there?
JENSON:	Whose Sparky?
TOPPER:	(*Whispering.*) Mr Peabody's ferret, he must have come down the hole.

SCENE 5
The Anderson Shelter

PAT's wrapping up her stuffed animals in little blankets, with PAULI helping her in the top bunk.

SIMONE is writing, ANIA sits by the door worried.

PAT:	(*Arranging her teddy bears.*) When I get married I'm going to have six children, three boys and three girls.
PAULI:	I'm only having boy children.
SIMONE:	We're not having children, are we Neely?
NEELY:	No. We're having rabbits instead.
PAULI:	I'm marrying Mum.

ANIA: Don't be silly Paul. Mum's married to Dad.
And one day she'll get old and die.

PAULI: No she won't.

ANIA: 'Course she will. If people didn't die we'd all
be stuffed on top of each other everywhere.

PAT giggles.

PAULI: But I don't want mum to die.

ANIA: She could die tonight. Right now. If a bomb
hit her.

PAULI stares at her.

You never think of anything for yourself, do
you? I have to think of everything just cause
I'm the oldest.

PAULI: That's not my fault is it?

ANIA: Go to bed.

PAULI: But it's not my bed time.

ANIA: (*In a rage.*) Mum said I was in charge while
she's away and if you don't do exactly as I
say I'll get Mummy to write to Daddy and
say you've been bad and he won't love you
any more or send you postcards and he
probably won't ever come home again.

PAULI bursts into tears but ANIA is unmoved.

*The girls sit shocked in the shelter as
PAULI sobs.*

SCENE 6
The City

FIREWATCH: It's getting dark now
The city hunkers down

MR SWAN: Across the park now

The trees are waiting

No shelter

For the trees

MR PEABODY: The swans are nesting
Their heavy heads
Beneath their wings

MRS SWAN: We're not protesting
We know the music of the bombs

MR SWAN: We shelter underneath
The stars

MRS SWAN: The only roof
Our snow white wings

FIREWATCH: And just now and then
They lift
Their heads
As if to
Taste the breeze

SWANS: And brave in the park like soldiers
Stand the trees.

THE CHORUS stand staring at the sky.

FIREWATCH: The sky is bright tonight
It's a good night
For fighting

TOPPER: Here Sparky, come here boy…

LARRY: It's quite a sight tonight
A boy might find it
Exciting…

NESTER: I got him! No it…I don't know what it is
– urrrgggghhhh…

LIZZY FORD: And under bits of steel
The girls are keeping
Their heads down

MRS SWEENY:	Bruno, come on boy, I've got your bone, nice bone from the butchers – just how you like it…
ETHEL:	They don't know what to feel They're even taking their beds down…

Two girls walk past with a makeshift bed.

CHILDREN:	And when we're big We'll all do

As we please
And brave in the park like soldiers
Stand the trees.

MATTY:	Here mister, want a look at the moon? Only thruppence. Show you the mountains up there, grey as flannel they are. Grey as ash and big as I don't know what. Only truppence. That's a good deal that is. For a look at the moon.

SCENE 7
The Anderson Shelter/
Front Room of Mr Peabody's

Everyone sits subdued, listening to the distant bombs.

PAT:	What if Mum don't come back?

Silence.

What if Mum don't come back and Jenson gets killed in the raid.

ANIA:	(*Listening to the bombs.*) You'll get yourself in a state you will.
TOPPER:	No need to thank us Mr Peabody…
SAM:	He's dead fast, isn't he, your Sparky?
PAULI:	If your mum got killed she'd go to heaven.

PAT: But I don't want her to go to heaven.

PAULI: You can talk to someone even when they're dead, but they don't talk back in words. That's what Mr Burke said. They talk back in feelings.

JENSON: My name's Jenson, I'm staying at number 37.

TOPPER: He's the conchie. He ain't nothing to do with us really.

SAM: Got a picture on the wall of their boy Jack who went and got killed first week he was out there, got run over, got himself run over…

TOPPER: My brother Mickey got shot over there. Mum buried his jumper in the garden, and she puts flowers on it, like it was a grave only, he ain't there, is he? It's just a jumper.

PAT: My dad's dead. He lives in a hospital in the sky.

PAULI: Is he all on his own?

PAT: He has his dog from when he was little. Patch.

ANIA: They don't allow dogs in hospitals.

PAT: (*Firm.*) They do in heaven. He sits on Dad's lap now and when I talk to Daddy I say… we're in London. You probably wouldn't like it because there's nowhere for your bike.

They listen to the bombs.

SCENE 8
The Anderson Shelter

Thunder.

The GIRLS and PAULI are bailing out the shelter with pots and pans.

ANIA: We got to get everything properly dry.

PAT is wringing out blankets, when she finds something.

PAT: You seen this?

Everyone looks.

PAT holds up the little pigeon box.

(*Stunned.*) Empty.

PAULI looks at her, aghast.

PAT: Must have got out.

ANIA looks at PAULI.

ANIA: Be here somewhere Pauli.

PAULI's bottom lip starts to go.

ANIA: Let's all look for him…

They all start searching.

PAULI: (*His tears coming.*) He'll be scared.

ANIA: Be alright – you'll see.

They search, but find nothing.

PAULI: He's all alone out there.

ANIA: He'll come back in the morning.

JENSON appears in the doorway.

Pauli's lost his pigeon and it's your fault.

JENSON: How'd you work that one out?

ANIA:	(*Totally over-reacting.*) There's too many people in here.
	She stares at JENSON.
JENSON:	We'll go then.
	A long beat, while they stare at each other.
	Come on Pat.
	PAT stares at him.
	Get your stuff.
PAT:	But what about Mummy?
JENSON:	We'll leave her a note. Go down one of the big shelters.
PAT:	(*Panicked.*) But it's dark.
	They stare at each other.
JENSON:	You coming or what?
	She doesn't move.
	ANIA smirks.
PAULI:	I'm going too.
ANIA:	(*Grabbing his arm.*) No you're not.
PAULI:	I'm going to look for Pete.
ANIA:	Sit down Pauli.
PAULI:	I got to go and look for him.
ANIA:	Do as you're told.
PAULI:	If Pete ends up dead it'll be your fault.
	JENSON looks at PAT one last time, PAT can't stand his gaze, she looks at the floor. JENSON grabs his bag and leaves.
	Everyone stands, sits in shocked silence.

ANIA: It was his choice. He didn't have to go, did he?

SCENE 9
A basement cellar of a bombed out building

The bombs thunder in the distance.

JENSON stumbles in to take shelter, he hunkers down pulling his coat around him.

Suddenly a shape emerges out of the darkness.

VOICE: This is my place, so hop it.

JENSON peers into the darkness.

Blow me if it isn't the conchie.

TOPPER comes out of the shadows.

TOPPER: Couldn't make it to Ladywell, had to stop off here. And there ain't room for two.

JENSON: I aint going back out there.

TOPPER: You are if I say you are. You got no right to shelter, not with being a traitor.

JENSON: You got no right to take a place out here when you got a basement of your own to shelter in.

TOPPER: Can't stay there no more. (*Confident.*) I'm leaving. Striking out on my own.

Beat.

Going down Southampton, stow away to South Africa or somewhere. You better not tell no one.

JENSON: What's your mum say about it?

TOPPER: She doesn't care.

TOPPER looks at JENSON.

It was Mickey she cared about.

Beat.

JENSON: My uncle got shot in the head.

TOPPER looks at JENSON, surprised.

JENSON: Our Gran looks after him now. He's like a baby, can't speak or nothing, just makes noises but Gran says she understands him.

The BOYS listen to the bombs falling.

TOPPER: You can make loads of money in South Africa. I'll come back when I'm twenty or something and I'm rich. Buy Mum a house. I don't mind working. Make my money over there then I'll come home.

JENSON: You don't reckon your mum will miss you then, if you go?

TOPPER: No. I don't reckon she will. All she ever does is shout.

SCENE 10
The Anderson Shelter

PAULI sits miserably holding the empty pigeon box.

PAT: You made Jenson go outside in the raid.

ANIA: I never made him do anything.

PAT: If he gets killed it's your fault.

ANIA: It is NOT.

PAULI: If he did get killed he'd be in that hospital in heaven with your dad.

PAT: Mummy will never forgive you.

ANIA: It's not my fault I'm the oldest. I have to make DECISIONS.

PAULI: Mum told you to look after everyone and now my pigeon's gone and Jenson's probably dead...

Everyone looks at ANIA.

SCENE 11
The bombed out building

Birdsong. Dawn.

The all clear sounds.

JENSON looks out at the coming light.

JENSON: You going to Southampton then?

TOPPER sits there, cold and miserable.

TOPPER: (*Trying to mean it.*) Yeah.

JENSON: You aint even got a kitbag.

TOPPER looks at him.

If you're going to stow away, for a long sea voyage, you need stuff, don't ya?

TOPPER looks at him.

Food, dried biscuits, compass, toothbrush... you got to have a toothbrush 'cause you can never go to the dentist again.

TOPPER: Why not?

JENSON: Got to keep your identity secret. You can't let them trace you.

TOPPER: Right.

JENSON: And you need stuff you can barter with...

You won't last long, without stuff like that. I got a list from this comic of mine, what you need to stow away.

TOPPER: Have ya?

JENSON:	Yeah. You want to see it – when we get back?
TOPPER:	Yeah. Alright.

SCENE 12
The Anderson Shelter

Birdsong. PAULI looks hopefully out the door.

PAT:	How we going to tell Mum that Jenson's dead?
SIMONE:	We best be going. Aunty Lou's unravelling a few jumpers this morning and she says I can have the wool she doesn't want.
NEELY:	I'm going to knit a vest for a soldier.

PAULI pulls back the blanket on ANIA's bunk bed.

But it's empty.

PAULI:	Ania's gone.

Everyone looks.

SCENE 13
In the street

JENSON and ANIA walk separately through the rubble.

LIZZY:	A hundred houses lie in ruins
BENNY:	A hundred bedrooms open to the air
WINKS:	Pictures on the wall Overcoats on hooks
FIREWATCH:	Toothbrushes in mugs Papers Books
MRS PEABODY	A hundred people never going home
MR PEABODY	A hundred well worn chairs

MRS SWEENY:	Money for the gas
PETE THE POST:	Porridge in the pan Carpet hanging off the stairs.
LARRY:	This was number forty with the dodgy bell
ETHEL:	This was number fifty with the roses
MRS SWEENY:	Now it's only floorboards And a bit of rug
FIREWATCH:	Why it's happened nobody supposes
LIZZY:	A hundred people climbing into daylight
MRS PEABODY	A hundred families reeling
LARRY:	Picking up a picture Searching for a coat
ETHEL:	Staring at a bit of ceiling
FIREWATCH:	Only last night this was home Now they're in the street alone And everything they knew is gone.

ANIA walks miserable.

ANIA:	Pete! Pete. Come on! You got to come back. We got your box and your special bread and everything. Come home, please.
LARRY:	All across the city
ETHEL:	Day is dawning
BENNY:	Everyone's uncurling
WINKS:	Cats are yawning
FIREWATCH:	That's another night retreating
PETE THE POST:	Voices start to rise in greeting…
MRS PEABODY:	You alright Maureen?
MRS SWEENY:	Lost my frying pan with the sausages still in it

	Where's Bruno? Bruno, come here!
LARRY:	All across the city Smoke is drifting
MRS PEABODY:	Everyone is searching Stumbling, sifting
BENNY:	Here's another day beginning
WINKS:	Here's another chance at life…

ANIA finds JENSON sitting alone wrapped up against the cold.

She looks at him a long time.

ANIA:	You didn't get killed then?
JENSON:	No.

Beat.

ANIA:	What you got there?

JENSON shows her his bag.

ANIA:	(*Amazed.*) Pete! Pete! It's you. How'd you find him?
JENSON:	Pauli got me to put a ring on his leg with Morse code on it.

ANIA sits down beside JENSON and strokes the pigeon.

He was under a crate near the sweetshop.

ANIA:	And you carried him around – all night?
JENSON:	Couldn't leave him there all on his own.

JENSON sits not knowing what to do.

ANIA:	You think about your dad sometimes?
JENSON:	Yeah. Think of him on Saturday. That was when we did things.

ANIA:	It's Saturday today.
	Beat.
	We just got to wait until all this is over, haven't we?
JENSON:	Yeah.
ANIA:	Our dads, they'll come back home…
	JENSON nods.
	We're only eleven…
JENSON:	Twelve…
ANIA:	That isn't old.
	She gets up.
	We should go back now, we got to strip the beds. That's the rule. Then we can have breakfast and we'll show you where there's mice living behind the radio. Mummy doesn't know. We feed them peas.
	She stands up. He follows her.

SCENE 14
The Anderson Shelter

PAULI stands with the pigeon inside his little box.

PAULI:	(*To JENSON.*) I think you should get a medal for rescuing Pete…
	SIMONE arrives with NEELY.
SIMONE:	Look what we've just found down the corner…a real trident…
ANIA:	(*Gathering up blankets.*) That's a toasting fork I think you'll find…

SIMONE: It's a trident which means we can now
 include an underwater scene in the play with
 Gods and Goddesses…

 PAULI rummages in his things.

PAULI: Instead of a medal – you can have this……

 PAULI gets the Acme Thunderer out of his bag.

 The Acme Thunder. It's the best whistle in
 the country, probably the world…

 *He puts the whistle around JENSON's neck. All
 the children pick up their things, and walk away.
 JENSON is left alone.*

 *He holds the whistle as it hangs around his
 neck.*

 THE END

OF THE TERRIFYING EVENTS ON THE HAMELIN ESTATE
Philip Osment

PHILIP OSMENT

Philip Osment's plays include: *Four Plays For Young People* (Oberon Books) commissioned by Theatre Centre and Red Ladder, *Little Violet*, published by Oberon Books (joint winner of the Peggy Ramsey Award); *The Dearly Beloved* (Winner of Writers Guild Award), *What I Did in the Holidays, Flesh and Blood* and *Buried Alive* commissioned by Mike Alfreds.

His radio plays have been heard on the BBC including a dramatisation of H G Wells' *The Time Machine* broadcast on Radio 3 in February.

Translations include *Pedro the Great Pretender* by Cervantes for the Royal Shakespeare Company, and *Kebab* for the Royal Court. (Both are published by Oberon Books.)

His play *Duck!* (Oberon Books) was the Christmas show at the Unicorn Theatre 2007/8.

He is currently writing a play about fathers in prison for the National Youth Theatre.

He also directs, teaches acting and runs writing workshops in Deal with Noel Greig: www.dealingwithwriting.com

Characters

CHORUS

MAXINE

JASON

ALI

LITTLE GIRL

NAN

CHILD

LEADER OF THE COUNCIL

MRS OKONEDO

MP

WOMAN

MAN

PIED PIPER

COUNCILLOR 1

COUNCILLOR 2

COUNCILLOR 3

COUNCILLOR 4

PRIME MINISTER

SPEAKER

MP 1

MP 2

MP 3

INTERVIEWER

ALI'S NAN

POLICEMAN

Of the Terrifying Events on the Hamelin Estate was first performed by St Michael's Church of England Primary School, Camden at the Unicorn Theatre, on 9 July 2008, with the following cast:

Shelpi Ahmed , Megane Barlow, Amina Begum, Yeasmin Begum, Erblina Berisha, Liam Cziraki, Nyamoc Deng, Veton Derguti, Tennae Drysdale, Nosasu Erhabor, Zabirul Hassan-Miah, Hana Khadir, Rasheada Khatun, Chadrak Louisela, Hysnathom Mabiala, Mustakeem Miah, Joblond Moussassi Makaya, Abdul Mumin, Jade Mutua, Ammad Saddiq, Abu Shaher, Tahmina Sultana, Osea Tamani, Anisa Vatoci, Habib Wahid, Sabiha Wahid, George Walton

Director Trevor Williamson

Assistant Director Charlene Gordon

Unicorn Facilitator Sharon Aviva Jones

We are the kids of the Hamelin Estate.
We're like kids everywhere –
love Harry Potter, Spiderman, Dr Who,
we do what kids everywhere like to do.
We'd like to win Pop Idol,
or the Lottery,
or both.
Play for Arsenal
Or Chelsea,
I'd play for Arbroath.
(Who's Arbroath?)
I'd like to be Rooney
and play for Man U
I'd like to be Kylie
Or anyone who
is famous and rich
and on the TV –
a *Big Brother* winner,
a ce-leb-ri-ty!
I'd buy Mum a new kitchen
and Dad a new car
and my brother out the army,
make my sister a star.

MAXINE: What do you want Ali Hussein?

JASON: He wants to play for Arsenal.

ALI: I don't know.

MAXINE: I thought you were supposed to be the best
 footballer in the school!

JASON: He's rubbish.

MAXINE: No he's not.
 I seen him play.

ALI: I want my Nan's arthritis to get better.

MAXINE: You what?

ALI: It hurts her and she can't walk properly.

They laugh.

JASON: Loser!

MAXINE: Yeah, puss, puss, puss!

> Maxine Bailey
> is just like that.
> She's a bit of a bully
> as a matter of fact.
> And her friend Jason Somerville
> is a terrible pig.
> He never stops eating,
> he's mean and he's big.

JASON and MAXINE are bullying a LITTLE GIRL.

JASON: Let me have one.

LITTLE GIRL: I've only got two left.

MAXINE: Yeah, one for Jase and one for me.

LITTLE GIRL: I got to save one for my little brother.

MAXINE: No you ain't.

She grabs the GIRL's sweets.

Here, Jase.

JASON scoffs the sweets.

ALI: Give them back!

MAXINE: (*To the LITTLE GIRL who is crying.*) Here you can have the packet.

They leave laughing.

ALI: You OK?

LITTLE GIRL: Yes.

ALI: Here you can have one of mine.

He gets out a sweet.

LITTLE GIRL: Are you really going to play for Arsenal, Ali
 Hussein?

ALI: One day maybe.

Anyway!
It all began one summer when the council decided
to cut down on the rubbish collections.
The bins were full and there were black plastic bags
 piled up
all over the estate:
rotten fruit and fish guts;
chicken bones;
tin cans;
leftovers from somebody's takeaway –
tandoori massala,
doughnuts and chips
piled up together
to make a big stinking mix.
On those hot summer nights
you kept your window tight shut
or the smell from below
would make you throw up.
What a stink!
So strong!
It's minging!
What a pong!

ALI: 'Scuse me.

JASON: What?

ALI: I think you dropped something.

JASON: No I never.

ALI: That banana skin?

JASON: You can't eat banana skin!

MAXINE: Get a life, Ali Hussein.

> Then they came,
> out of the sewers,
> up the drains,
> from the floorboards,
> like Attila the Hun and his ravenous hordes!
> Invading the kitchen,
> taking over the flat,
> leaving their droppings
> on carpet and mat.
> Squeaking in the ceiling,
> pitter patter overhead,
> dancing a victory dance
> over our bed.
> They made our estate
> a miserable place!
> It was like an invasion
> from outer space.
> An alien pack,
> a verminous brood,
> getting stronger and bigger
> from eating our food.
> Rats!
> Big as cats!
> Rats in our flats,
> in the stairways and halls,
> rats in the cupboards,
> rats in the walls.

NAN: Oh no!

CHILD: What's wrong Nanny?

NAN: In the night…

CHILD: Yes?

NAN: I was asleep.

CHILD: Yes?

NAN: And I felt something.

CHILD: Where?

NAN: On my cheek.

CHILD: And then?

NAN: I put my hand up to my face.

CHILD: Yes?

NAN: And something ran away.

CHILD: Was it a…?

NAN: And I looked at my hand.

CHILD: What did you see?

NAN: Blood. My cheek was bleeding.

CHILD: Was it the…?

NAN: A rat had been gnawing at my cheek in the night.

LEADER OF THE COUNCIL: Mrs Okonedo, calm down please. The council is doing everything in its power to deal with the matter. You know my daughter and her family live on the Hamelin Estate so I do understand, but I don't know what more we can do. We've set traps and poison but the rats won't take the bait. And of course we've had to make cuts in our spending so our hands are tied.

MRS OKONEDO: A rat gnawed my Mother
I'm calling my MP.
It's an absolute disgrace.
She's bound to agree.

MP: Yes, Mrs Okonedo,
it is very bad,
but the council is inefficiently run.

Next time you must vote for us.
We wouldn't allow such a mess to be made
if we were in charge.

There were pictures in the papers.
My Dad went on TV.
Everyone agreed that this just shouldn't be!
They called a big meeting
about the ESTATE OF SHAME,
but everyone was looking
for someone to blame.

I blame the parents for not caring less.
I blame the youth for making a mess.
I blame the teachers,
politicians,
the cops –
they should be doing more
to make sure this stops.
I blame the judges
for not enforcing the law.

MAXINE: I blame our neighbours,
 they're filthy next door.

JASON: My Dad blames refugees
 spreading germs, commiting crimes.

I blame the media.
I blame the times!

In the middle of the meeting
there was a scratching at the door.

WOMAN: What was that?

MAN: It sounded like claws.

COUNCILLOR 1: A horrible noise.

WOMAN: Makes me feel bilious just to hear it.

MAN: Oh Lord preserve us,
 I'm going! Where's my hat?
 I'm terribly worried
 that it might be a –

PIED PIPER: Rat-
 a-tat-tat!
 I've heard chat
 that
 you got a problem?
 Fiction or fact?

 A weird-looking man!
 A tramp or a clown?
 His one eye was blue
 the other was brown.
 He had a mohican
 and rings in his nose,
 tattoos on his face,
 and as for his clothes!
 They were covered in patches –
 leather trousers and coat,
 and big leather boots
 and there at his throat
 was a scarf of dark red
 with a bright yellow stripe
 and attached to the end of it
 was some sort of pipe.
 And while he spoke
 his fingers would stray
 to that pipe round his neck,
 like he wanted to play.

PIED PIPER: I can help you.

LEADER OF THE COUNCIL: You? Help us? How?

PIED PIPER: I can get rid of your rats.

COUNCILLOR 1: How will you do that?

PIED PIPER: I have my ways.

COUNCILLOR 2: Have you got a licence?

PIED PIPER: A licence?

COUNCILLOR 2: Are you a member of the British Pest Control
 Association?

PIED PIPER: No.

COUNCILLOR 3: The man's an imposter!

COUNCILLOR 4: A con-man!

COUNCILLOR 2: A thief.

WOMAN: How do you know that?

COUNCILLOR 2: He's lying through his teeth.

PIED PIPER: Please,
 read these,
 letters from referees –
 bigshots from overseas –
 praising my expertise.
 I'm the bee's knees
 so they say.
 The Sultan of Brunei
 so pleased that I
 rid his house of flies.
 This one is from a President
 resident in Africa –
 cockroaches in his car and his coaches –
 till my pipe approaches my lips
 and every roach skips town.
 The Pope
 who couldn't cope
 so he said,
 with the interlopers in his bed.
 Bugs!
 He wanted them dead.
 One toot on my pipe

and they fled.
Dread, dread!
And Bill Gates,
who hates
a virus?
He had to hire us,
my pipe and me,
to disinfect his sites:
megabytes and megabytes
of tiny cyber mites
were soon deleted and defeated.
It's not that I'm conceited.

LEADER OF THE COUNCIL: And what would it cost?

PIED PIPER: Cost?

LEADER OF THE COUNCIL: We have limited funds.

PIED PIPER: I'm not greedy or needy
 One hundred pounds will do.

LEADER OF THE COUNCIL: One hundred-!
 A thousand pounds would be cheap.

 The very next morning
 he came to the Estate.

MAXINE: Uggh he's got a got spider's web on his face.

JASON: Hey mister, how you gonna get rid of the rats?

MAXINE: They'll take one look at him and run away in fright.

 And then he blew on the pipe
 and there came a strange sound
 echoing around the parking bays
 and walkways,
 a crazy amazing whistle and trill,
 until
 there was a hurrying and scurrying

from drains and sewers and walls
and rats poured out from everywhere:
scary long-tailed rats,
sharp teeth beneath
twitching whiskers
friskily following
the man with the pipe.
Down the High Street
past Euston Station
way down Holborn
to Waterloo.
People staring,
taxis blaring,
drivers trying to get through.
Near the Houses of Parliament
they went down to the river –

PRIME MINISTER: And so my Lord Speaker
I would like to suggest
that it is for local authorities to deal with such matters-

SPEAKER: I'm sorry, I have to interrupt you, Prime Minister,
but I've been handed a note saying that there is something
extraordinary going on outside.

And the MPs
deserted the House of Commons
and squeezed onto the terraces over the Thames
to watch the man in the leather coat
playing his pipe
in the mud by the river.

MP 1: Is it some kind of demonstration?

MP 2: Looks like a busker.
What's he doing down there?
Look out! The tide's coming in!

MP 3: Strange music!

MP 1: What's that following him?
Are those…?

An army of rats
followed him down
to the edge of the water
and all of them drowned.

Cheers from the watchers.

There were celebrations on the Hamelin Estate that night.
There was a tooting and hooting of horns,
a cheering and whooping from balconies and doors.
Uproarious parties in all the flats,
like when England's victorious
in a football match.
Mum made it up with the woman next door,
my uncle did a dance with his mother-in-law,
my sister let me borrow her favourite top,
my brother gave me money to buy sweets from the shop.
And my dad went mad plugging holes in the wall,
glad that the rats would no longer gnaw
at our homes and our food and our grandmother's cheek;
that we'd nothing to fear from a creak or a squeak.

JASON: Hey Maxine, did you see those rats drown?

MAXINE: Yeah it was wicked.

ALI: My Nan says even rats are Gods creatures.

JASON: That's probably because you're related to them, Ali
Hussein.

MAXINE: Good one Jase.
Anyway gotta go.
There's a TV crew coming to our flat.
They're going to film me pointing to the rat-hole in my
bedroom.

Then the leader of the council appeared on *Newsnight*.

LEADER OF THE COUNCIL: The infestation of rats on the
Hamelin Estate has been dealt with by the council in its
usual efficient manner and this shows how seriously my
party takes the well-being of council tenants.

INTERVIEWER: Is it true that you have family members living
on the Estate?

LEADER OF THE COUNCIL: My daughter lives there with her
little girl.

INTERVIEWER: And I understand that nothing you tried was
working and that it was the Piper who-

LEADER OF THE COUNCIL: It was our policy of laying traps
and poison that eventually paid off.

INTERVIEWER: You're surely not denying that the Piper led
the rats into the river!

LEADER OF THE COUNCIL: Undoubtedly a certain number of
rats were drowned on that occasion. But I find it difficult
to believe that rats can be disposed of simply by playing
a pipe.

INTERVIEWER: But didn't you agree that you would be paying
the Piper for his services?

LEADER OF THE COUNCIL: There was no contract with the
gentleman in question.
He is not even a member of the British Pest Control
Association. The Council does not hand out money willy-
nilly to individuals who make outrageous claims. Rat
infestations cannot be solved by magic.

> And just as he said that
> there was a commotion in the studio,
> and in the confusion the cameras swung round,
> and on our screens we saw him –
> the Man with the Pipe.

LEADER OF THE COUNCIL: This is outrageous. It's media
 hype!

PIED PIPER: You trying to deny
 that you said you were buying my services?
 You implying I was lying
 when I said I'd get rid of your rodents?
 Mystifying!
 I'm prophesying terrifying consequences:
 there will be sighing and crying
 and much wherefore and whying
 if you don't satisfy me
 by modifying your line.
 One hundred pounds was all I asked.

LEADER OF THE COUNCIL: He's threatening us! Did you
 hear that?
 Turn the cameras back on me. Thank you! The council will
 have no truck with extortion. He will not get a penny. The
 man's a thug and should be investigated by the police.

 But when the cameras turned back again
 the Piper was no longer there!
 He had just disappeared,
 he'd melted into thin air.

 On the Hamelin Estate we slept soundly that night,
 snug in our beds without taking fright
 at pitters and patters and squeaking and creaks,
 no clitters or clatters disturbing our sleeps.
 And then in our dreams we heard a sweet noise,
 a music that called to all girls and all boys
 to follow, to follow,
 for riches and fame,
 for a life of adventure,
 for love and acclaim.
 Houses with swimming pools,
 holidays in the sun,
 an endless supply
 of good food and fun.

Burgers and Playstations,
Nintendos and fries,
designer trainers in everyone's size.
In our pyjamas and nightshirts we went down to the street
some wore their slippers
some had bare feet.

MAXINE: Out of my way,
Let me get through,
I'm auditioning for *X Factor*
and I'm first in the queue.

JASON: I'm going to the Emirates
so get out my way.
I'll captain the Gunners
the next time they play.

We followed,
we followed,
and the music played on
past Mornington Crescent
and way beyond,
through the West End
and Trafalgar Square
where the lions ignored us
but we didn't care
and the tourists stood staring at the marvellous sight
Of children dancing down Whitehall at night.
Now at this point in the story you're worrying perhaps
that our fate will be similar to the fate of the rats –
you can see us all floundering,
mud up to our knees –
but that's not what happened
so pay attention please.
We crossed over the river
just by Big Ben
and along the embankment
and that is when

The London Eye came in sight
And it started to turn
in the dead of the night.

MAXINE: Look Jason! There in that Pod.
There's Simon Cowell
He's waving at me!

JASON: I can see Eduardo and Lehmann,
Fabregas, Flamini.

And the sirens were sounding
the police cars were near
but the sound of the pipe
was all we could hear.
The Piper was leading us into a Pod.

MAXINE: I'm going in the first one.

JASON: There's the rest of the squad.
Can you see them, Ali Hussein?

ALI: I think I can.

MAXINE: What are you waiting for then?

Ali was going to lead the rest of us in
when a voice called out over the noise and the din.

ALI'S NAN: Ali!

ALI: Nana?

ALI'S NAN: Don't go in there.

ALI: But I'll be a football star, Nana
And I'll earn lots of money
I'll be able to buy you a big house
and pay for you to see the very best doctors.

ALI'S NAN: But I don't need a big house, Ali,
 and you're the best doctor for me –
 your smile does me more good than any pills.

MAXINE: Are you lot coming or not?

ALI: What if it's a trap?

JASON: This ain't no trap
 I'm in here with Arsene Wenger
 He's gonna give me a contract.

 And Maxine and Jason got into the Pod
 And as they passed Ali they gave him a prod
 The rest of the children cried:
 WE'RE COMING TOO
 But Ali Hussein would not let them through.

ALI: Don't go in there!
 Remember the rats!

JASON: We ain't rats.

MAXINE: But you lot are all losers.

JASON: Yeah puss, puss, puss!

CHILDREN: We want to go with them
 Get out of our way!
 Let's push him over!

ALI: No children, stay!

 The doors were now closing
 With a clang and a hiss
 Maxine waved with a smile,
 Jason blew them a kiss.
 The children watched them
 rise into the air
 but then, all too soon,
 the next Pod was there.
 And we still heard the music

and we still heard the call
of the pipe and the Piper
which promised that all
our dreams and desires
would soon be fulfilled
after all we weren't rodents
we wouldn't be killed!

POLICEMAN: (*On megaphone.*) Step back from the Pod children,
Step back from the Pod.

And there were our parents
my Mum looked a wreck!
And the Leader of the Council, with a hundred pound
cheque.

LEADER OF THE COUNCIL: Piper, please come back. You've
got my granddaughter in there. Maxine! Please bring her
back. Please, I'll pay you anything.

Down by the Thames
Blue lights are flashing,
faces are ashen
looking up at the wheel.
The Pod is descending.
Our story is ending.
Does anyone know
what it will reveal?
The Pod is arriving
and everyone's striving
to look through the windows
open-mouthed and wide-eyed.
As the doors slide across
what a terrible loss –
no Piper,
no Jason,
no Maxine inside.

They made a documentary about what happened on
 The Hamelin Estate.
But then there were floods, and an election, and a war,
and no-one was interested in us any more.
The Leader of the Council offered a reward
for anyone bringing news of his adored
granddaughter Maxine.
But no news came,
the two children and the Piper
were never seen again.
The Council Leader still walks the streets with their photos
 in his hand.
He's now a much sadder and a much wiser man.
And Ali Hussein's
still a big Gunners fan –
he might play for the youth team –
and he still loves his Nan.
We learnt many things about what's right and what's not;
we learnt you should value what you've already got;
If you're greedy your dreams
might lead you astray;
and don't swindle the piper,
just make sure you pay.

THE END